Many thanks to Jack Bailey, Daisy Whitewolff, Yiyu Lam, Kristyna Baczkynski, Keeenue, Connor A, Laura Callaghan, Ed Cheverton, Donya Todd, Murray Somerville, Matthew Alker, Wolf Mask, Anna Wanda Gogusey and Liisa Chisholm

www.bellykids.co.uk

UnCage Nicolas

start

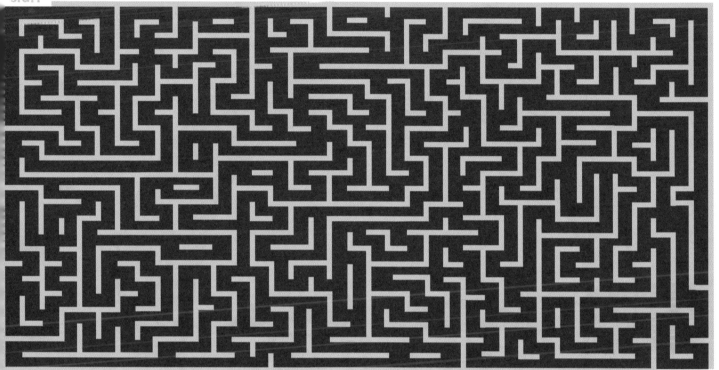

finish

PLANE HIGH-JACKED

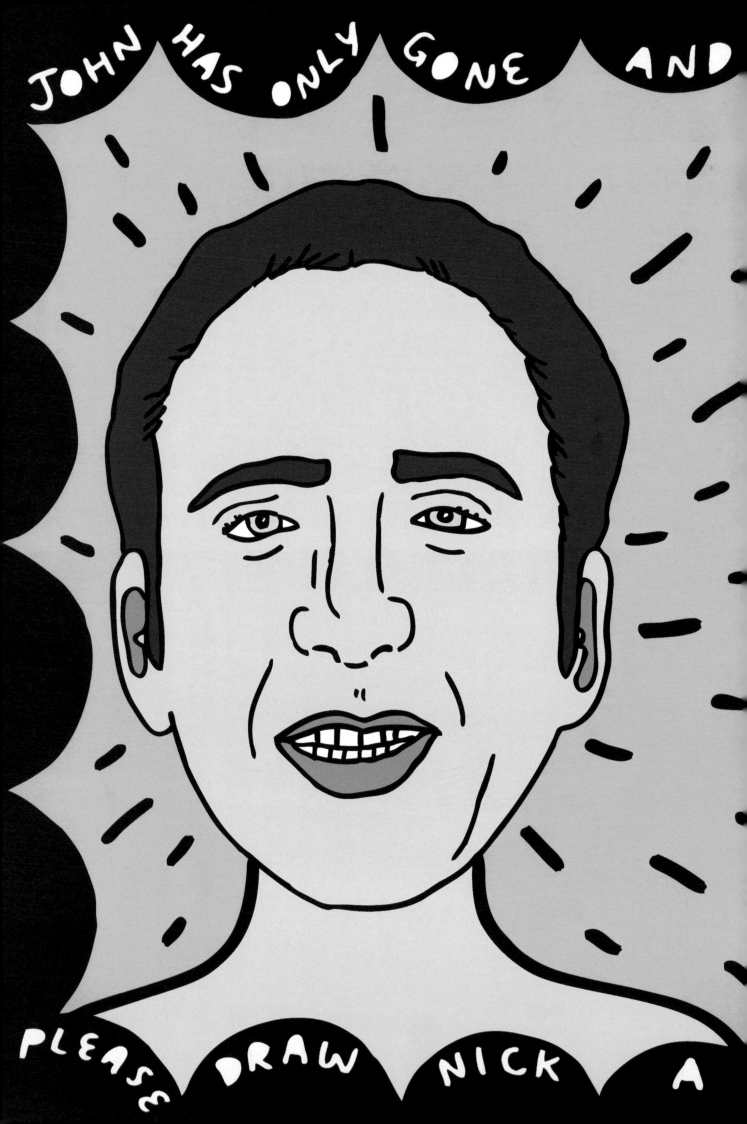

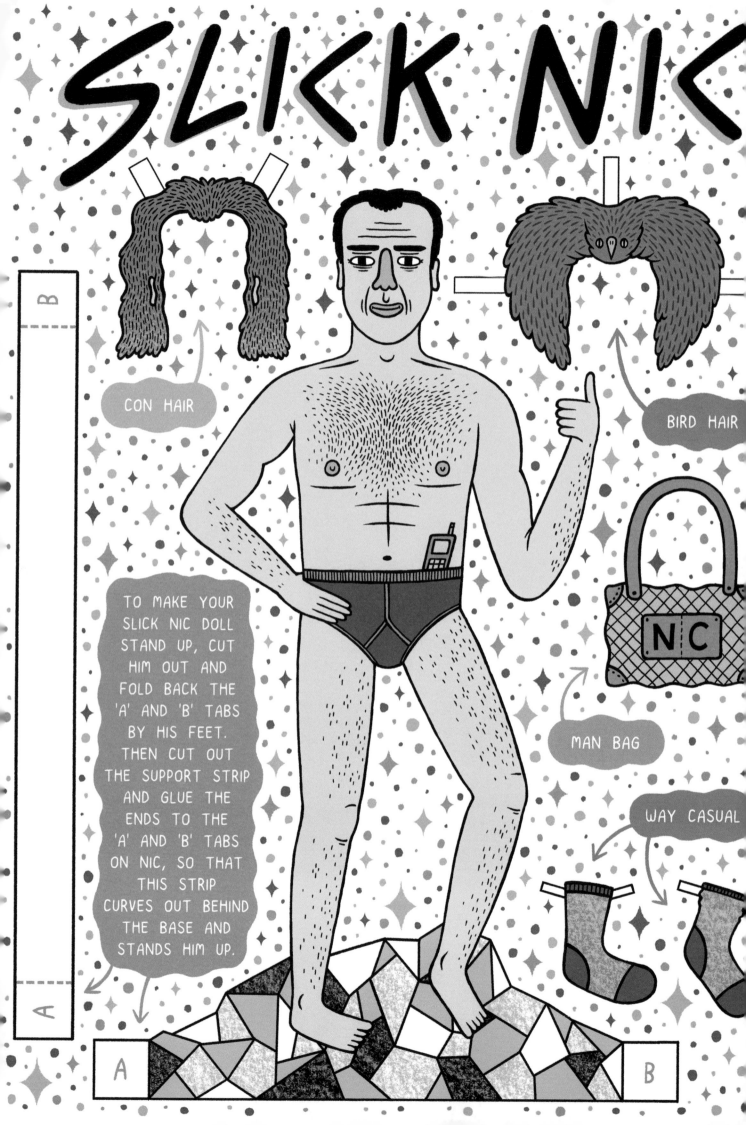

SLICK NIC

CON HAIR

BIRD HAIR

NC

MAN BAG

WAY CASUAL

TO MAKE YOUR SLICK NIC DOLL STAND UP, CUT HIM OUT AND FOLD BACK THE 'A' AND 'B' TABS BY HIS FEET. THEN CUT OUT THE SUPPORT STRIP AND GLUE THE ENDS TO THE 'A' AND 'B' TABS ON NIC, SO THAT THIS STRIP CURVES OUT BEHIND THE BASE AND STANDS HIM UP.

A B

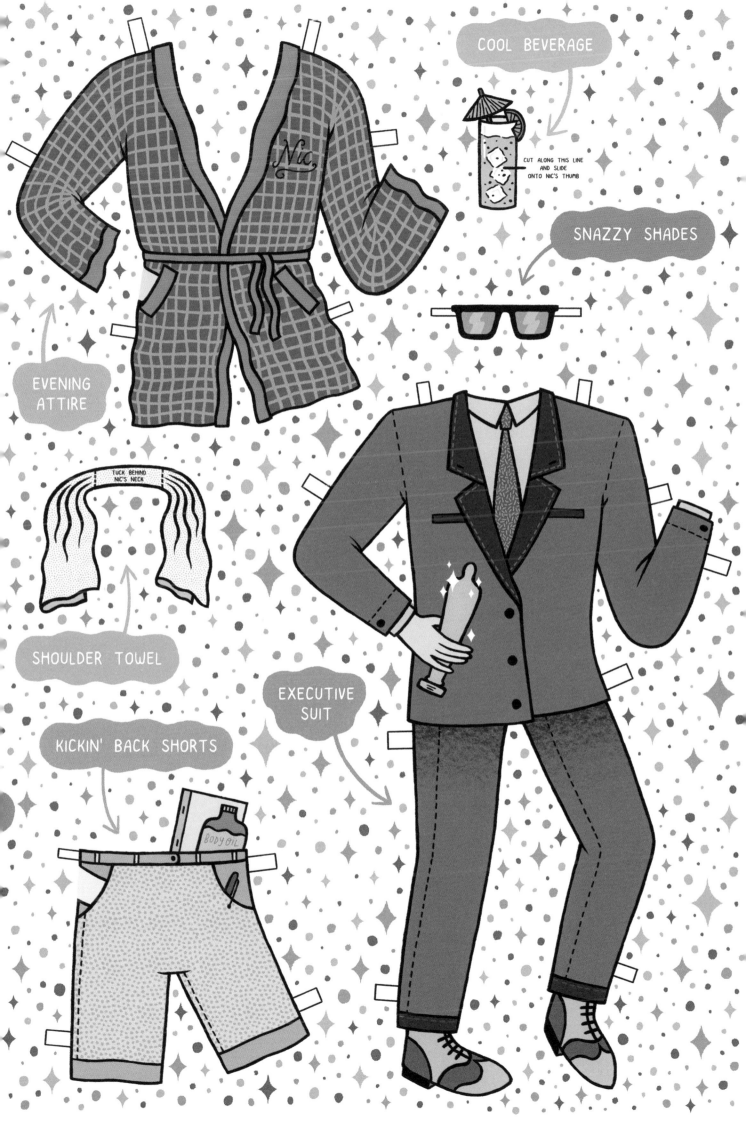

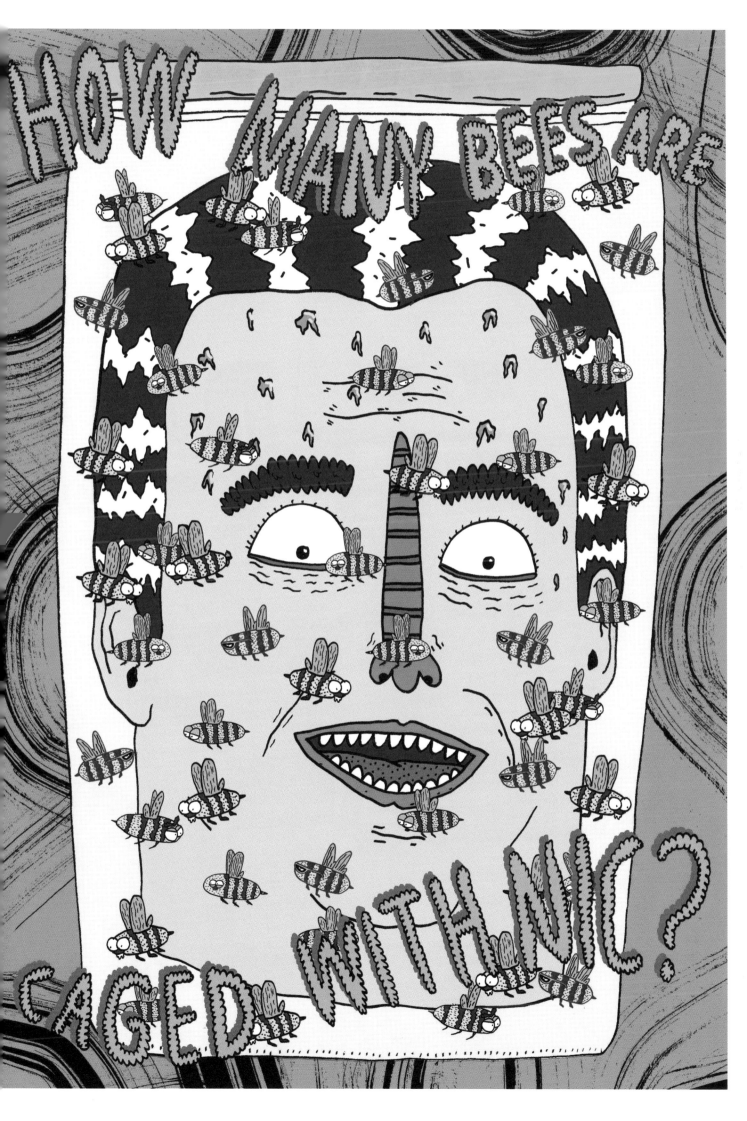

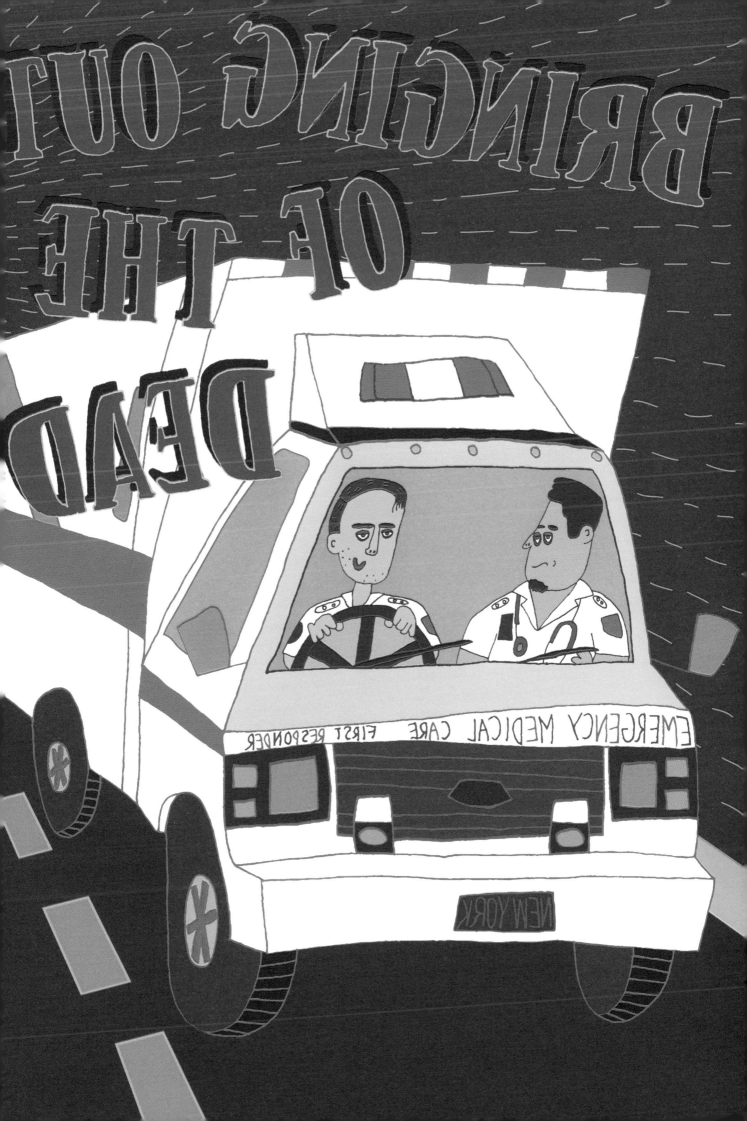

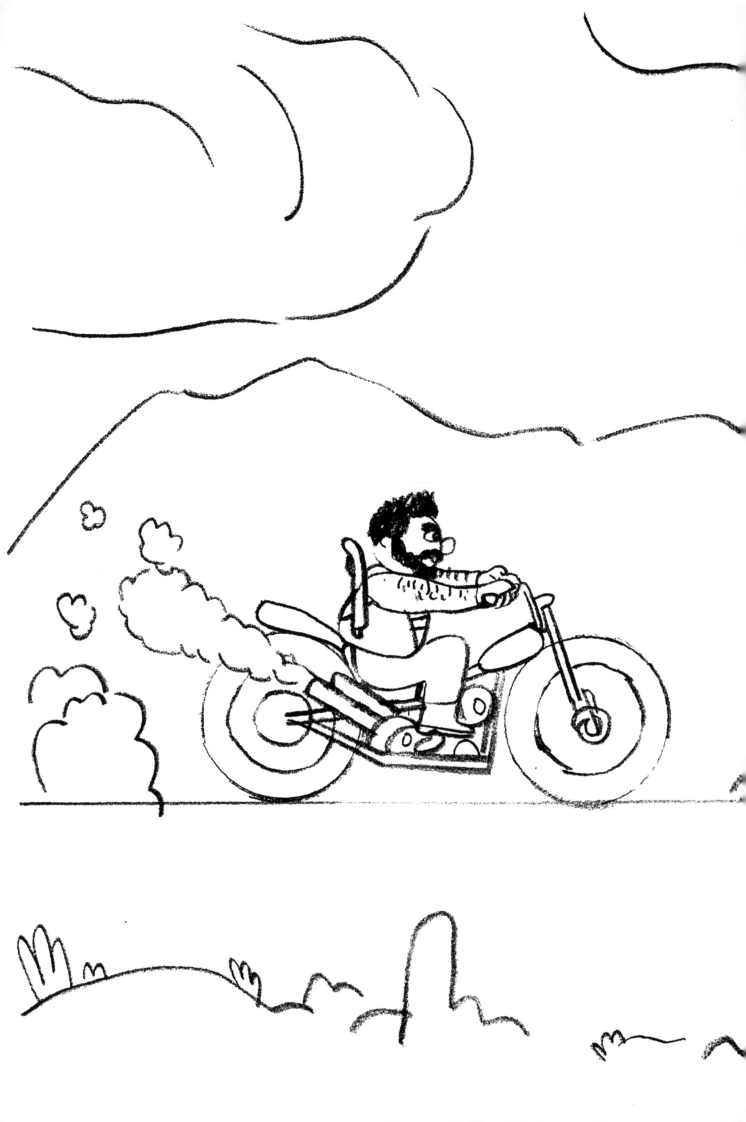

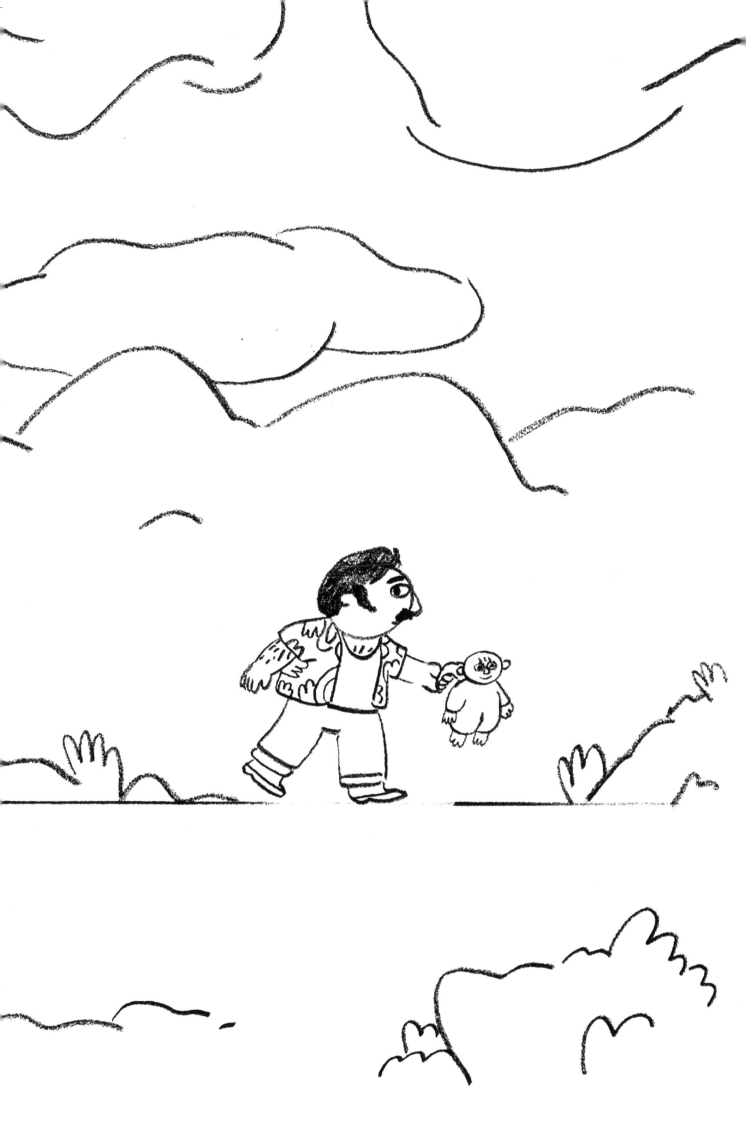

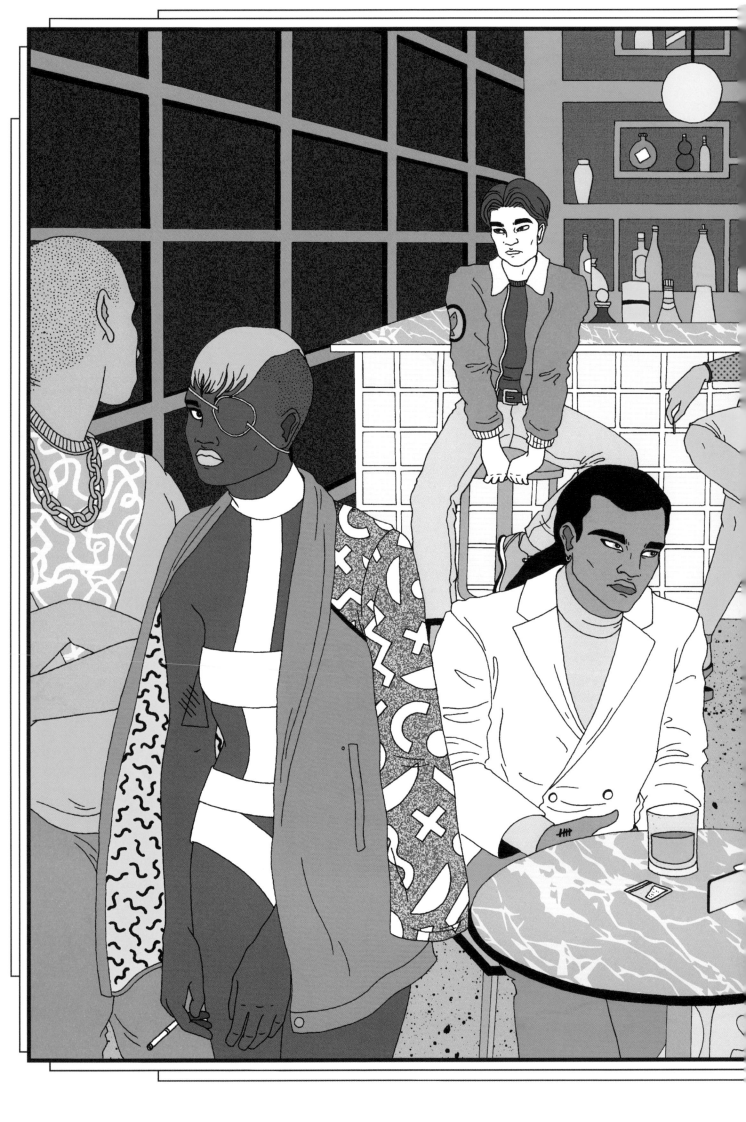

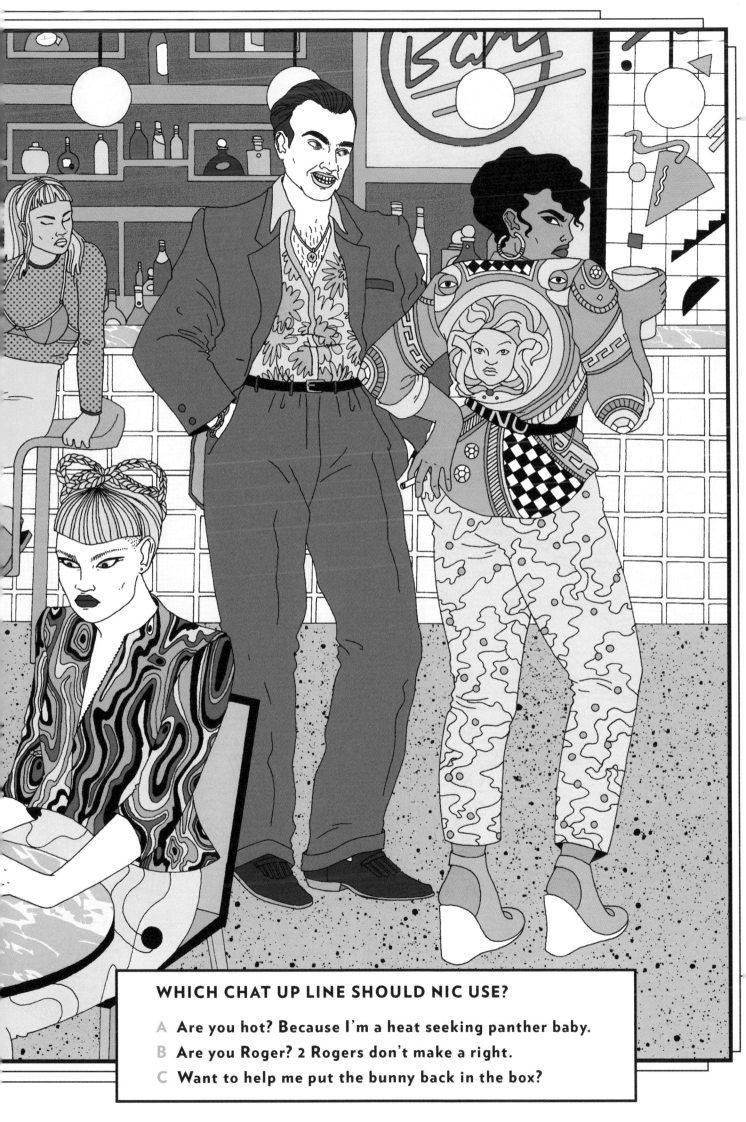

WHICH CHAT UP LINE SHOULD NIC USE?

A Are you hot? Because I'm a heat seeking panther baby.

B Are you Roger? 2 Rogers don't make a right.

C Want to help me put the bunny back in the box?

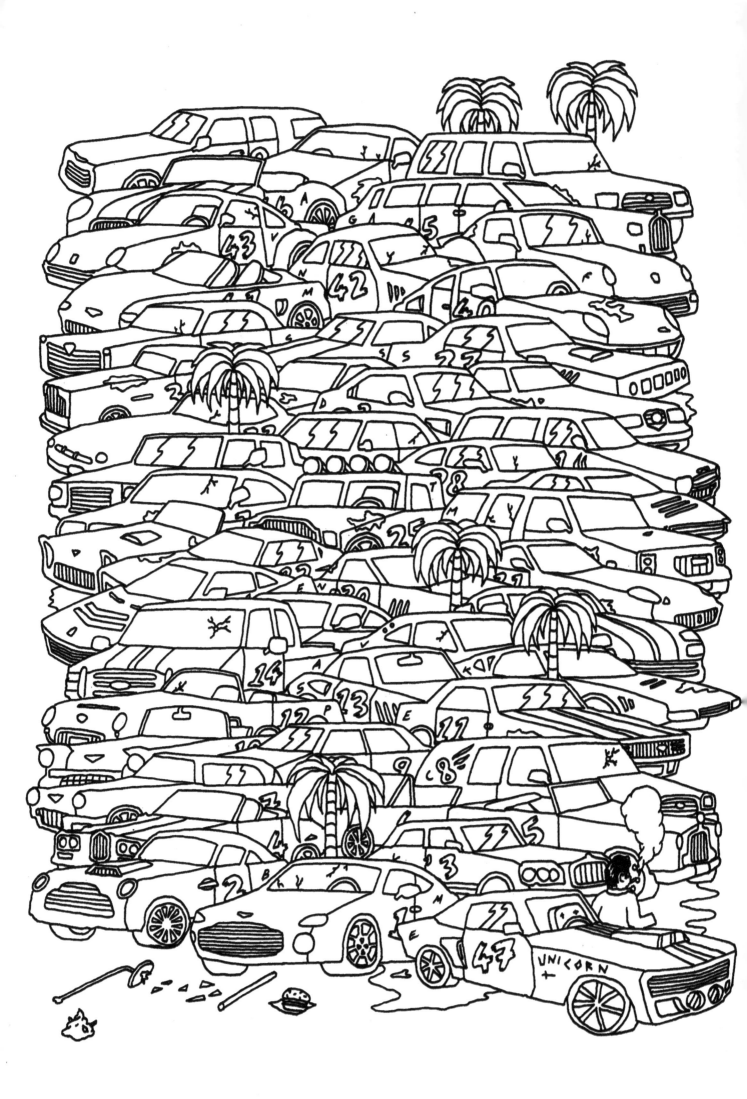

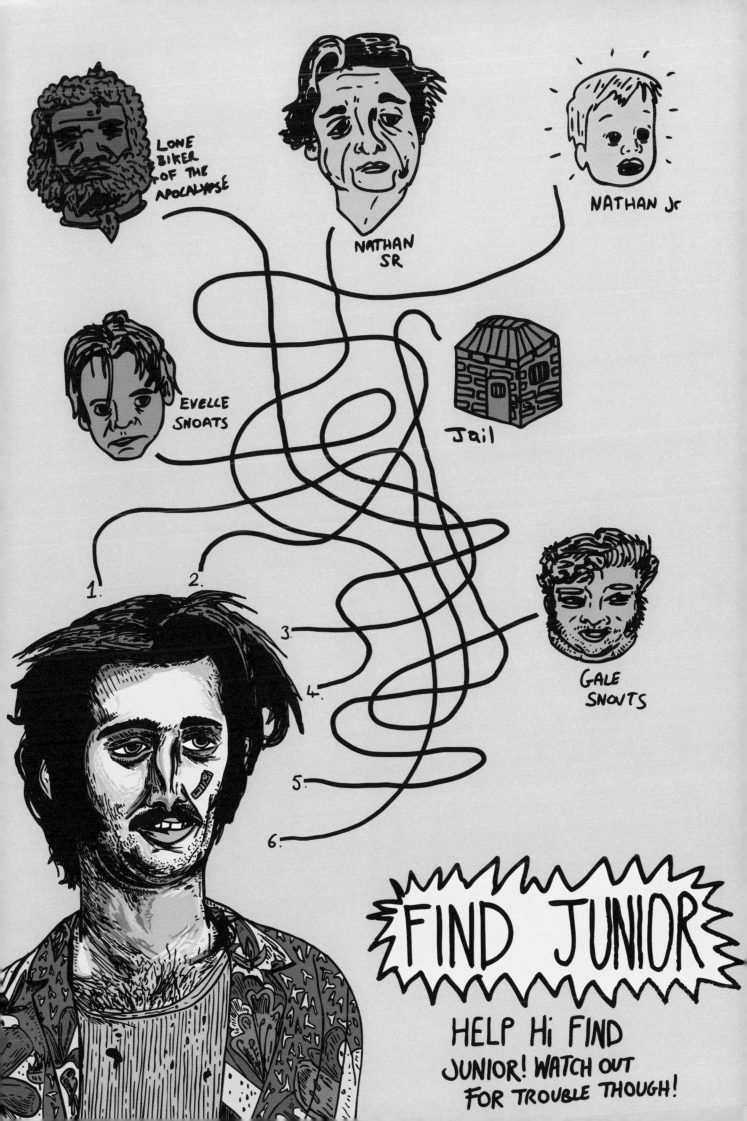

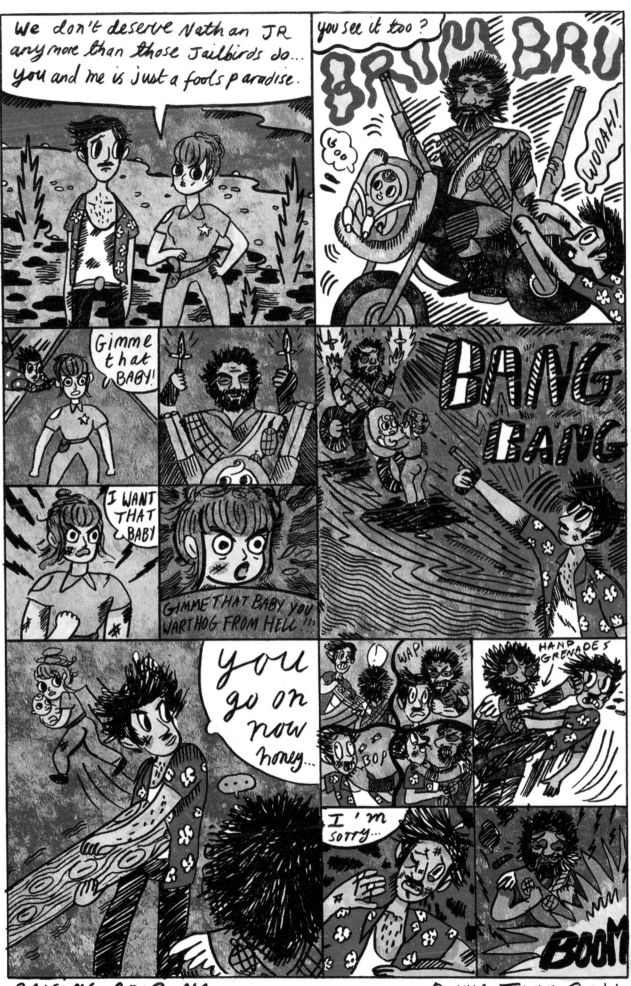

RAISING ARIZONA DONYA TODD 2014

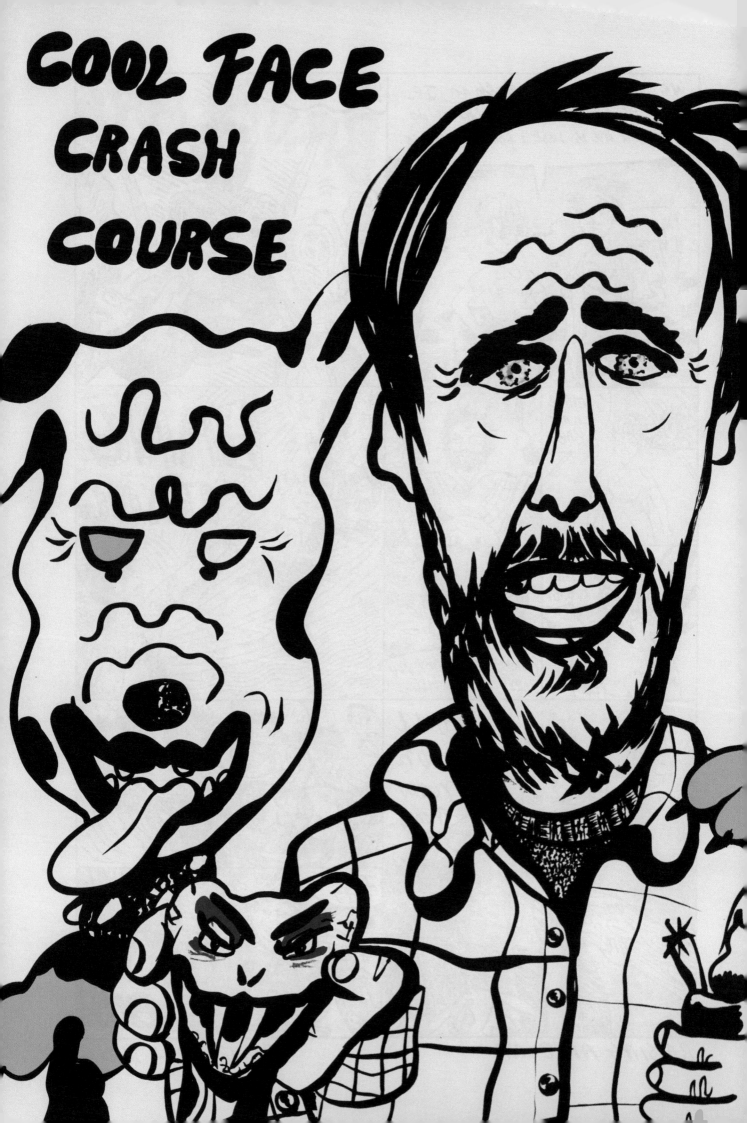

COOL FACE CRASH COURSE

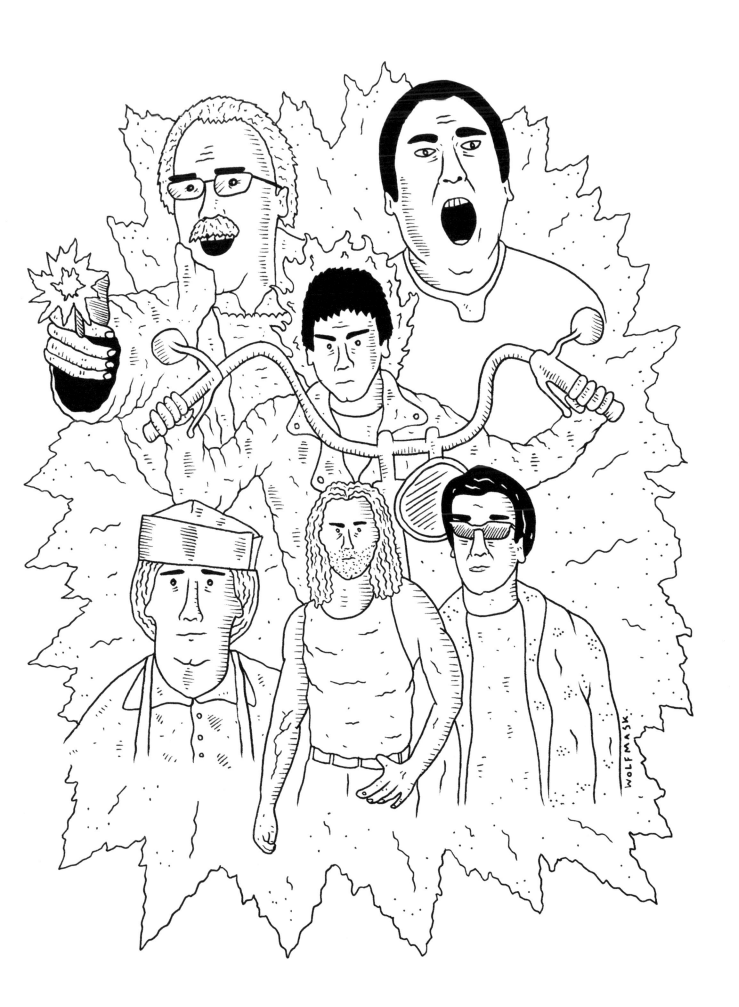

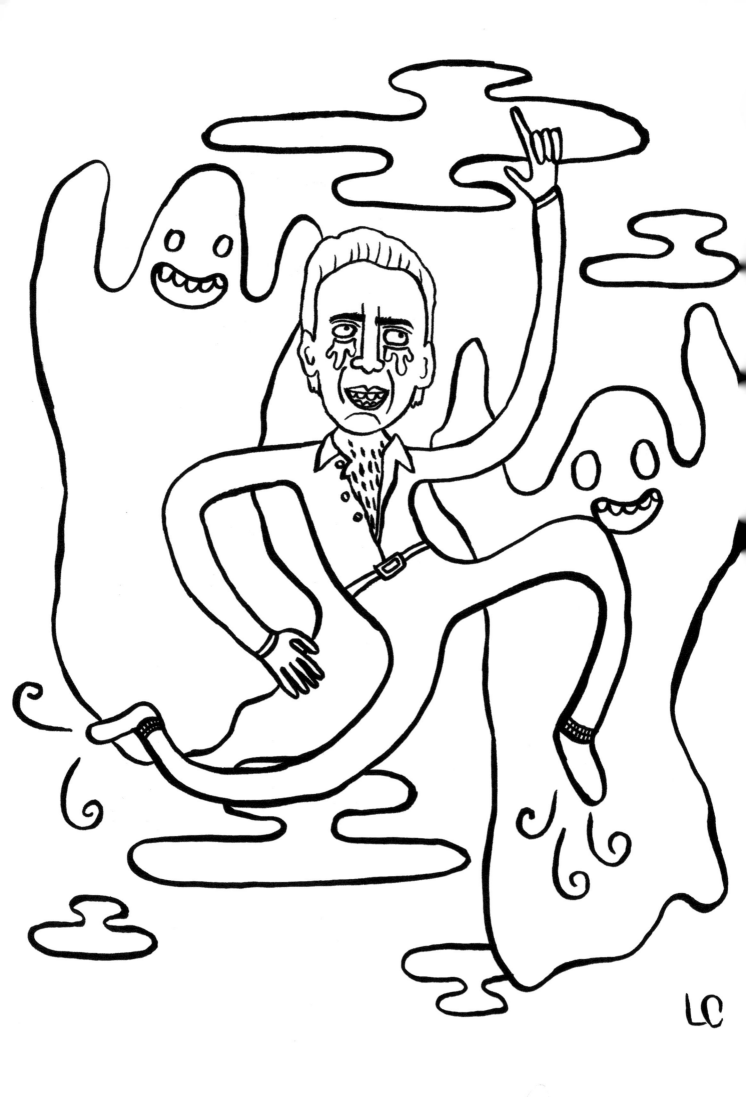

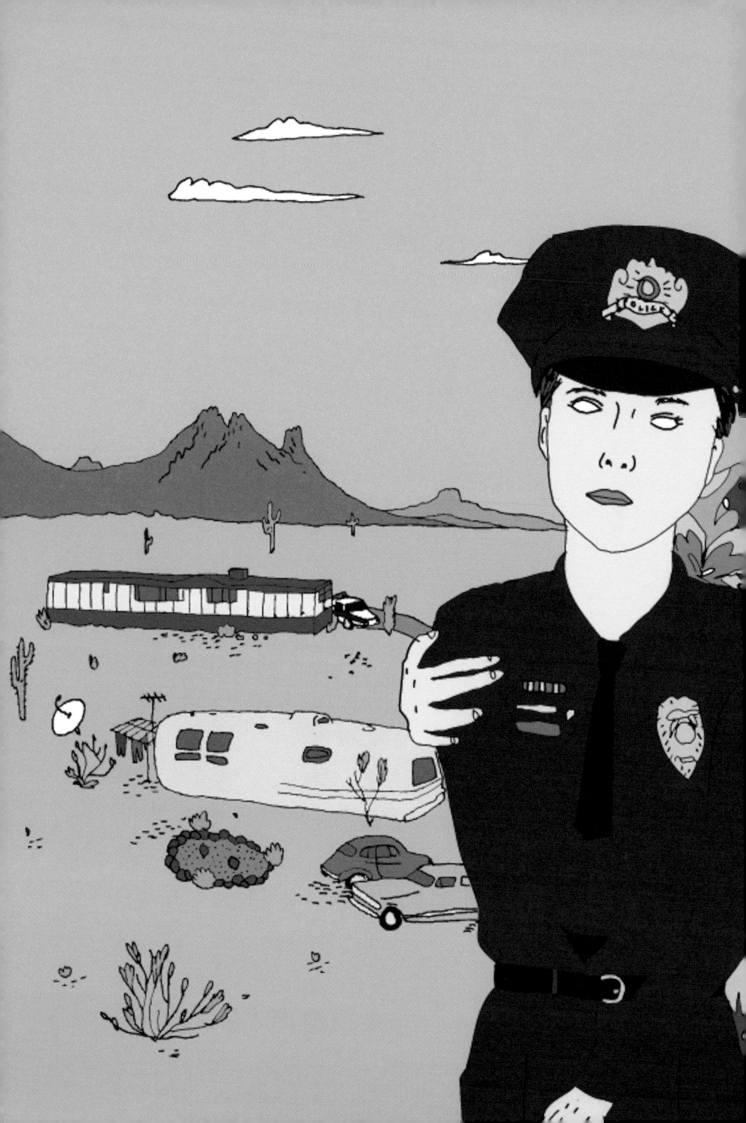

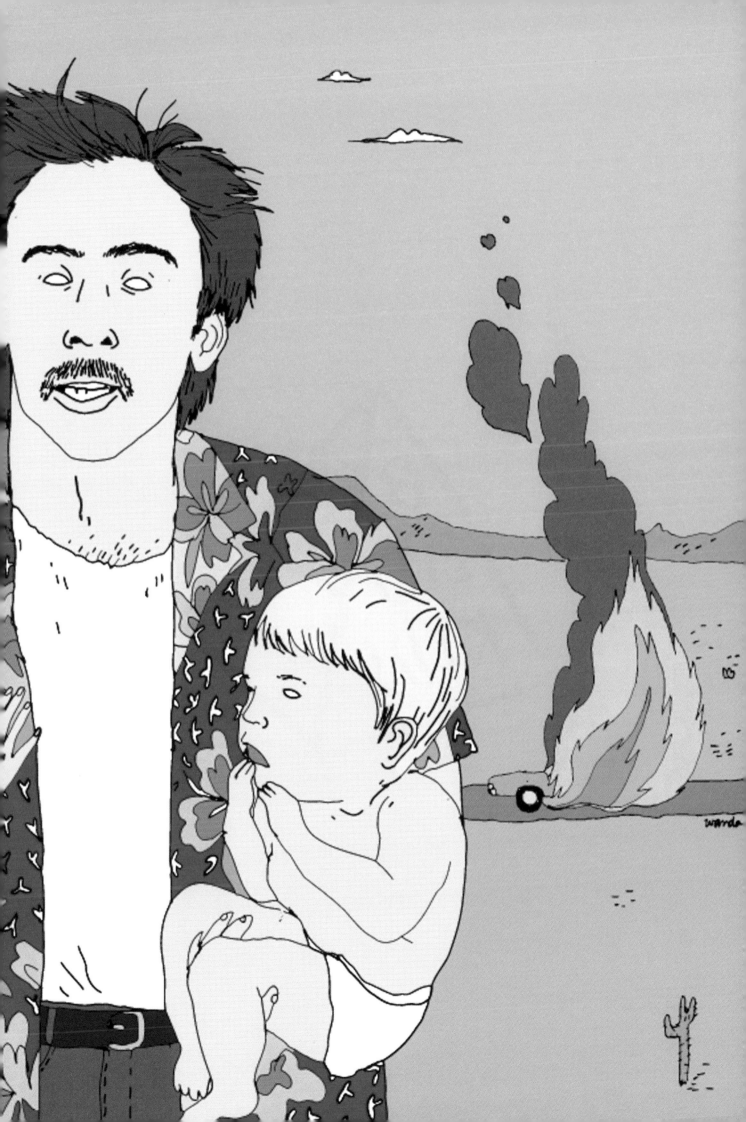